Coloring Book

Monster Doodles

Copyright ©Maryna Salagub

First Edition

All rights reserved. No part of this book may be reproduced in any form or by any means, electronic or mechanical, including protocopying, recording, or any information storage and retrieval system, without written permission.

Distributed by : CreateSpace

ISBN-13: 978-1535553544

ISBN-10: 1535553545

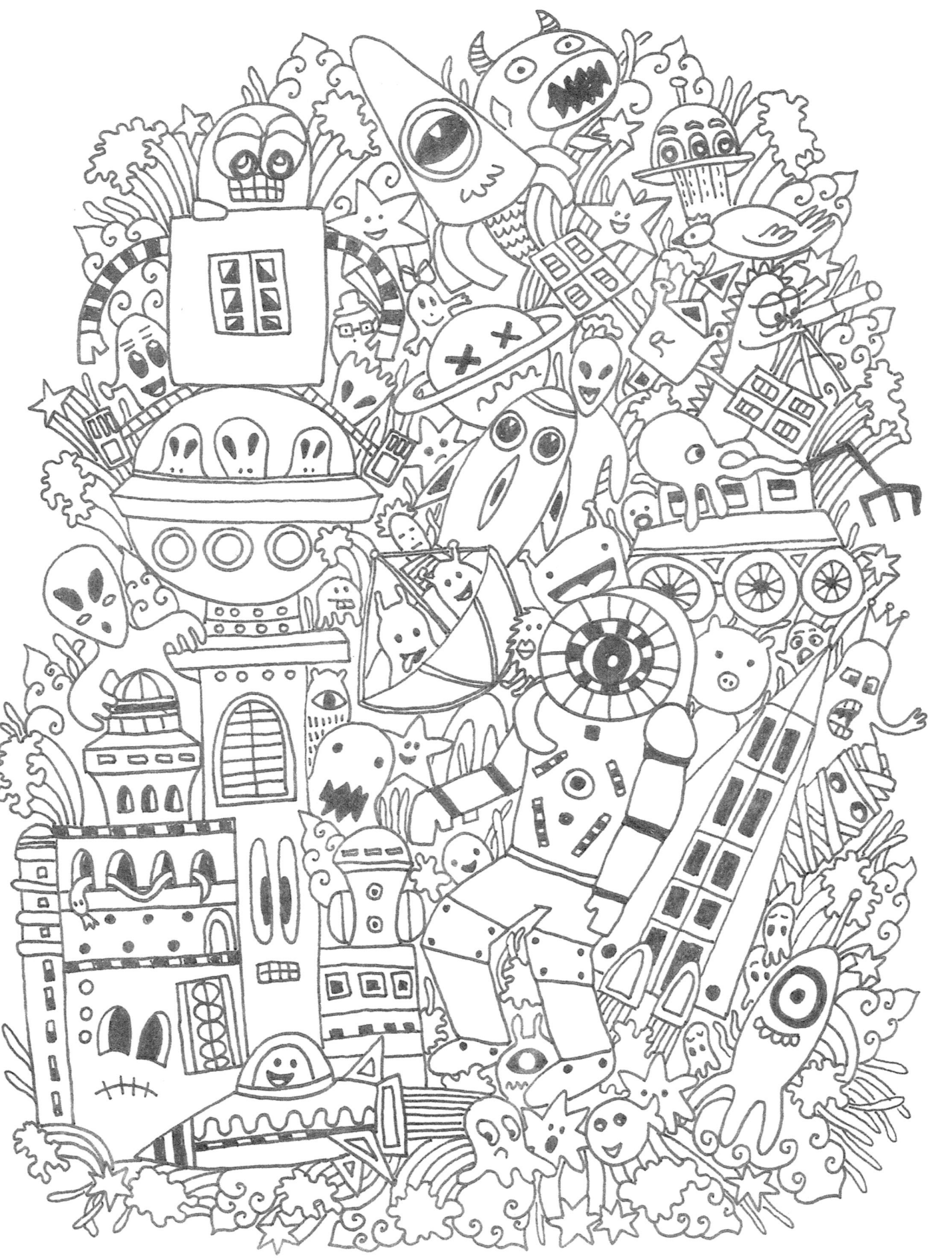

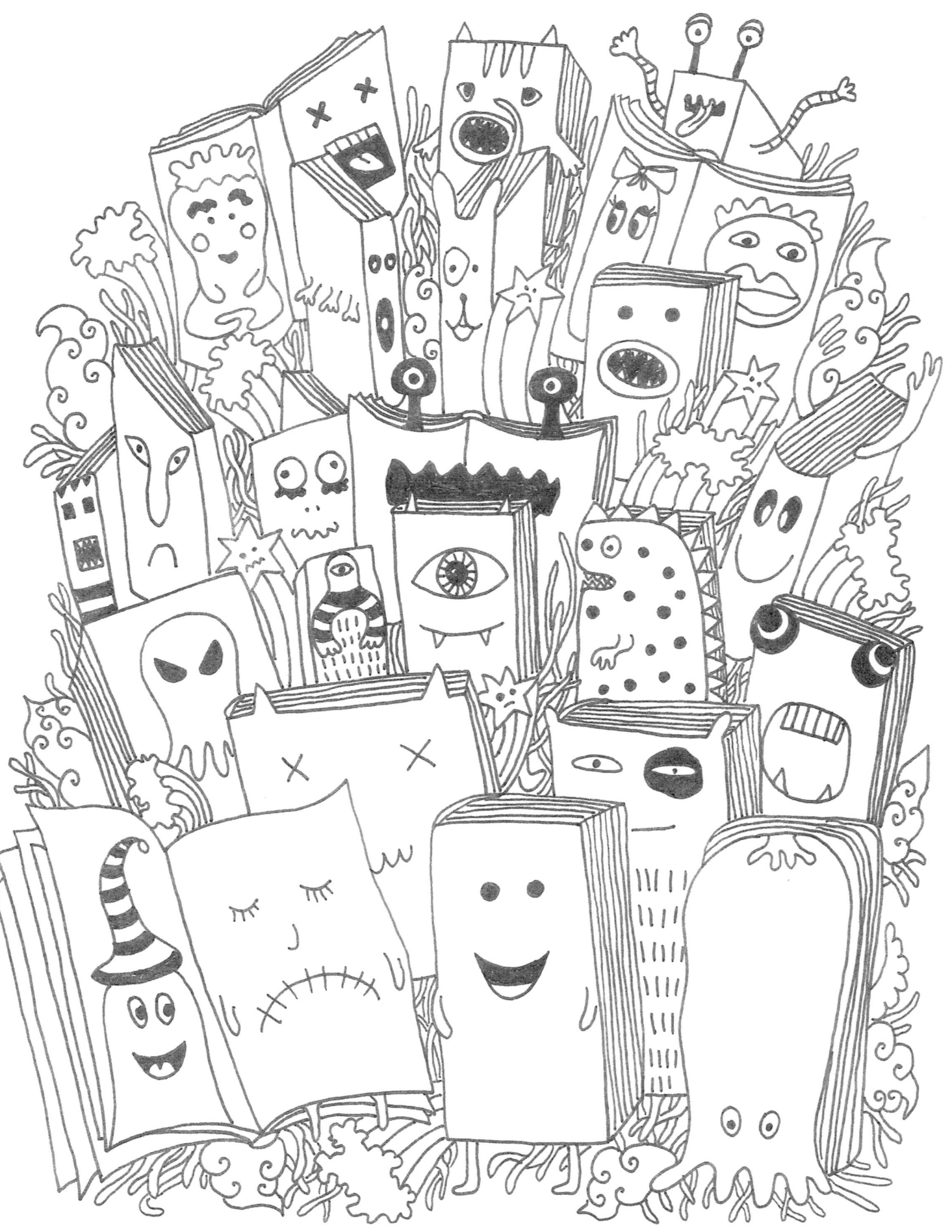

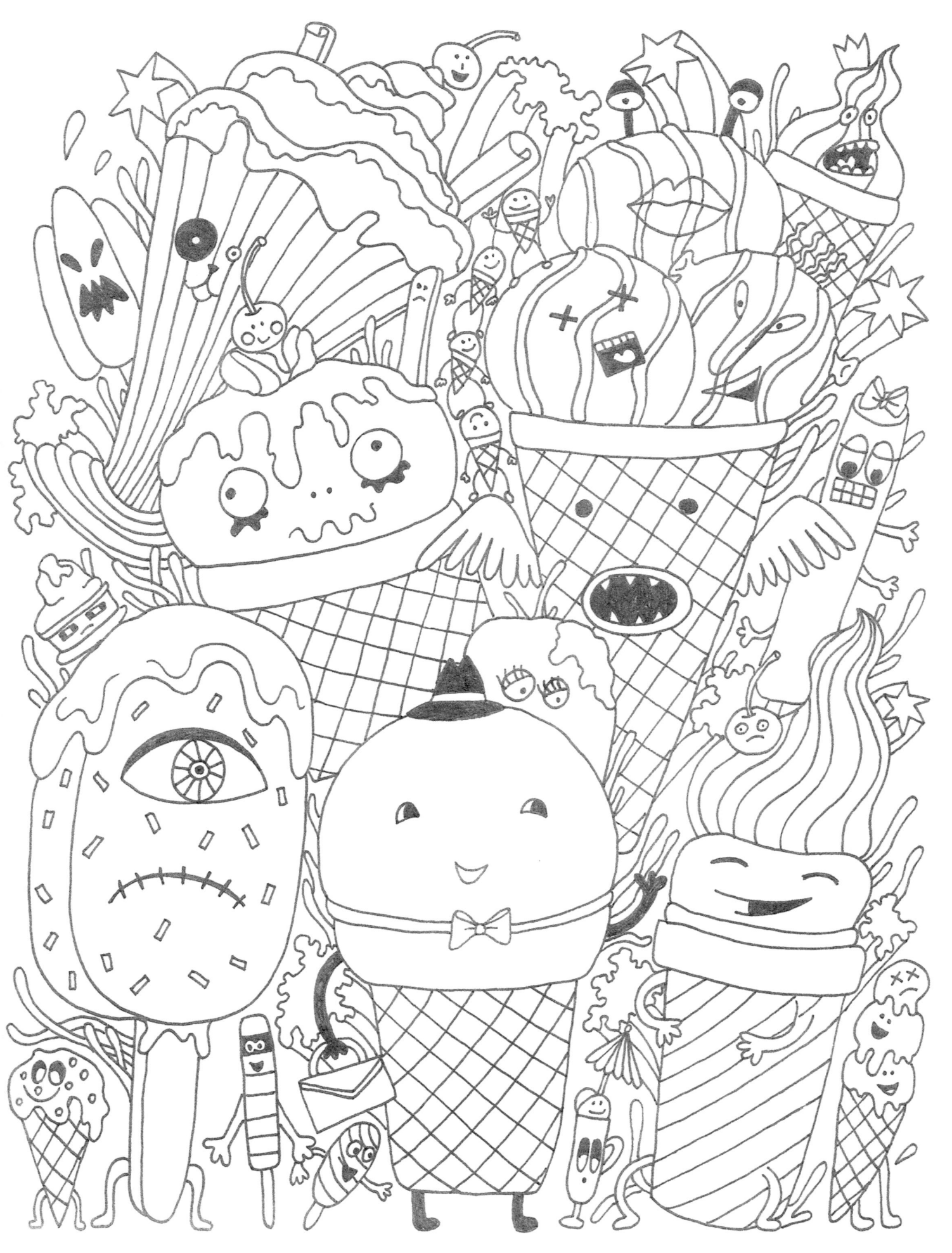

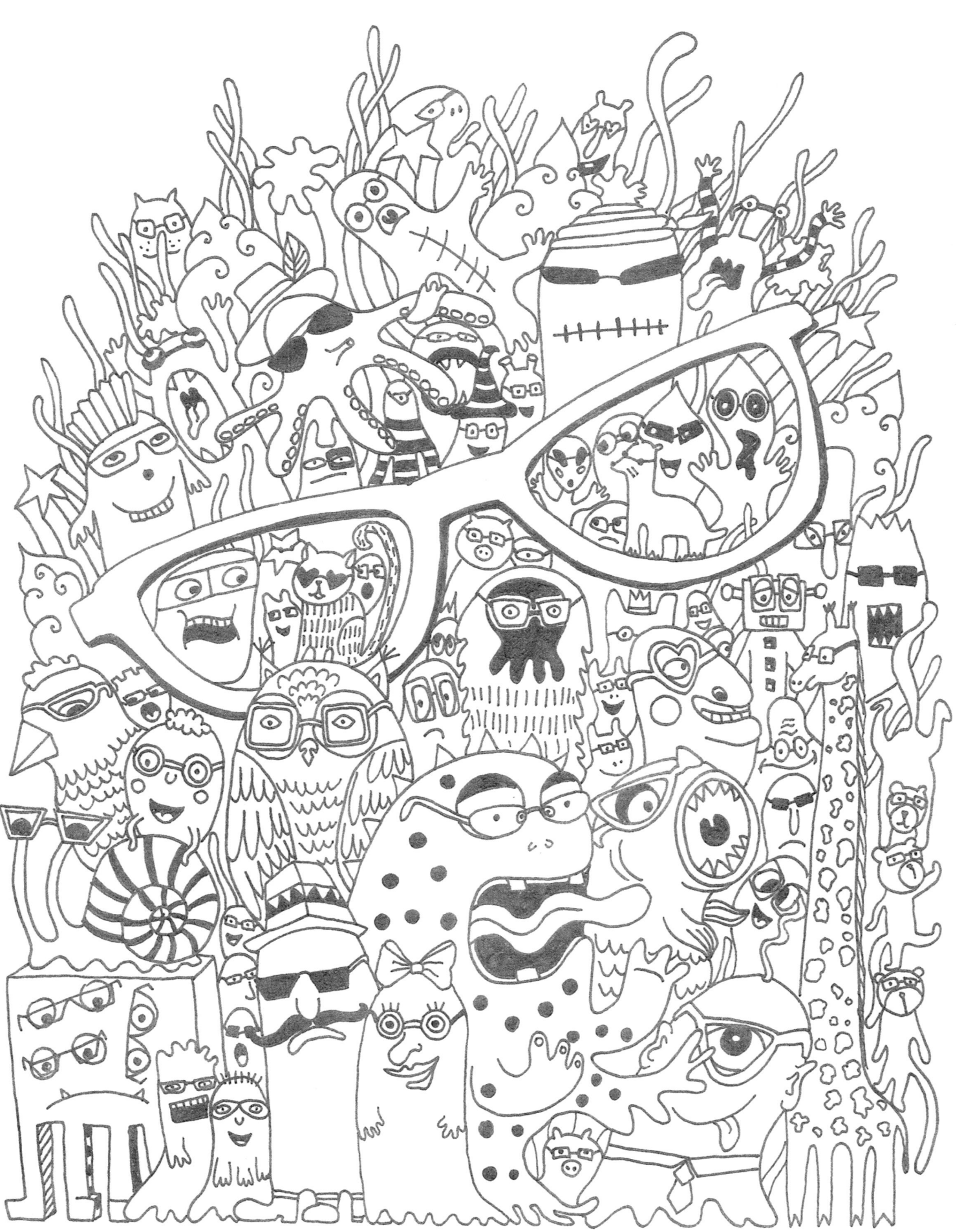

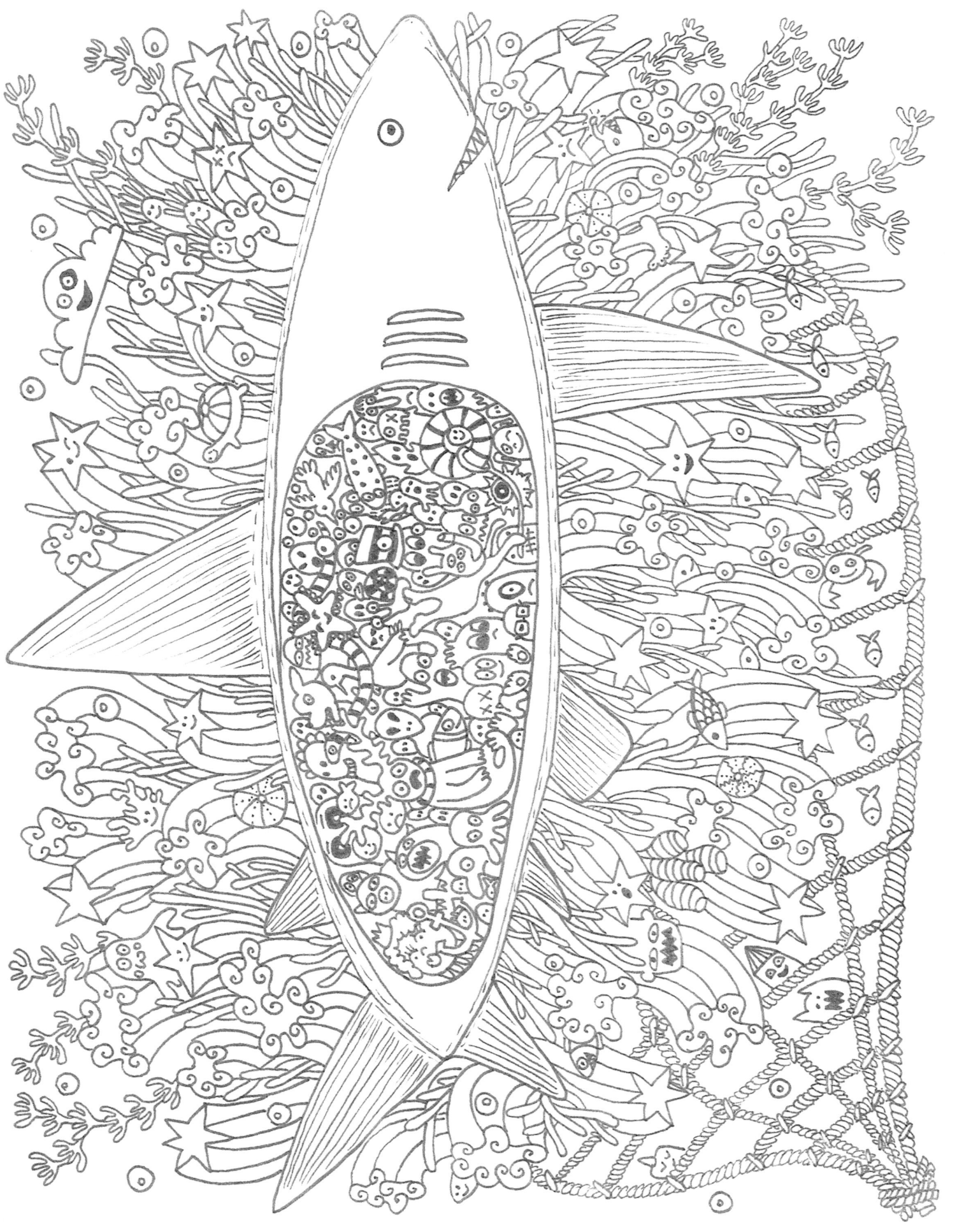

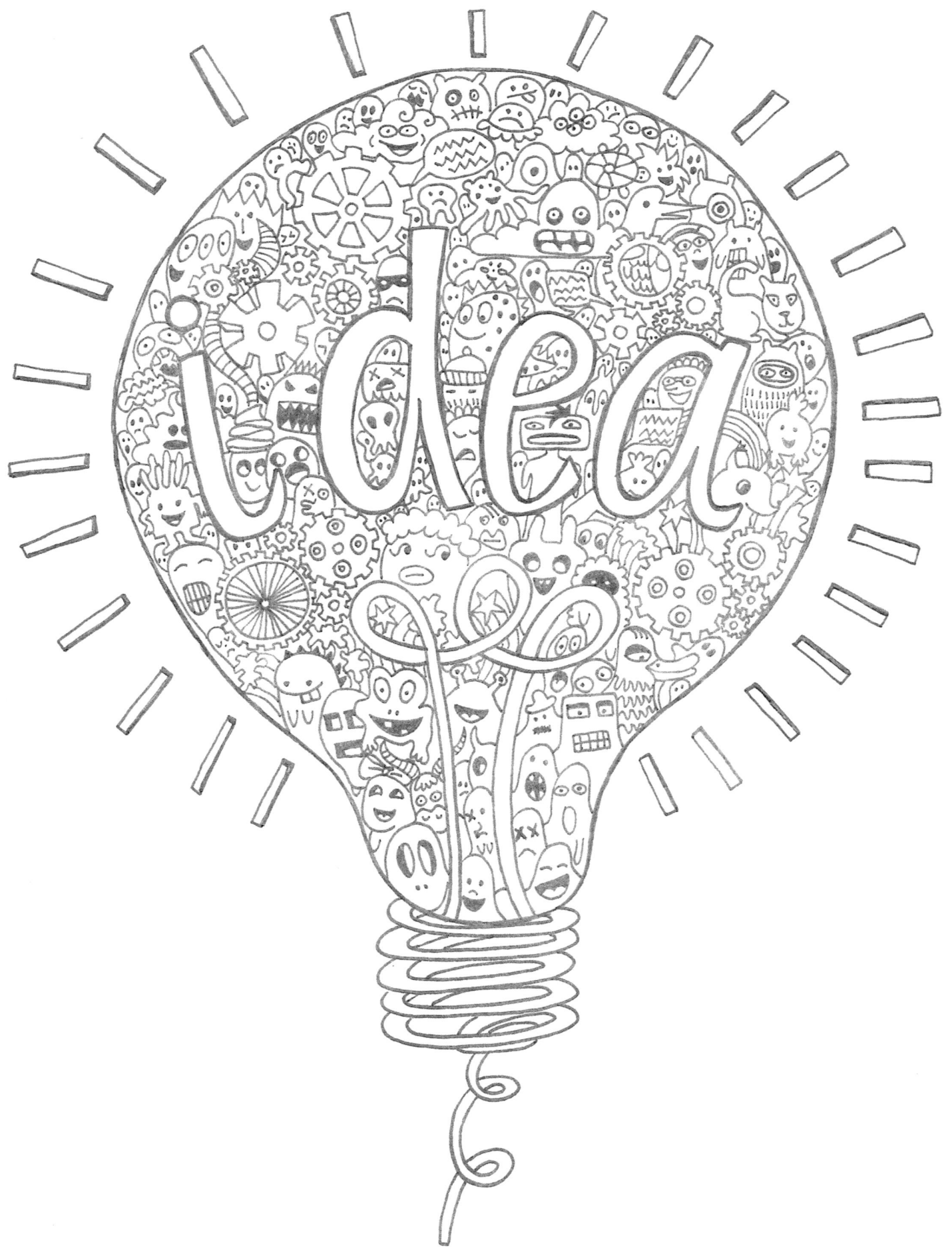

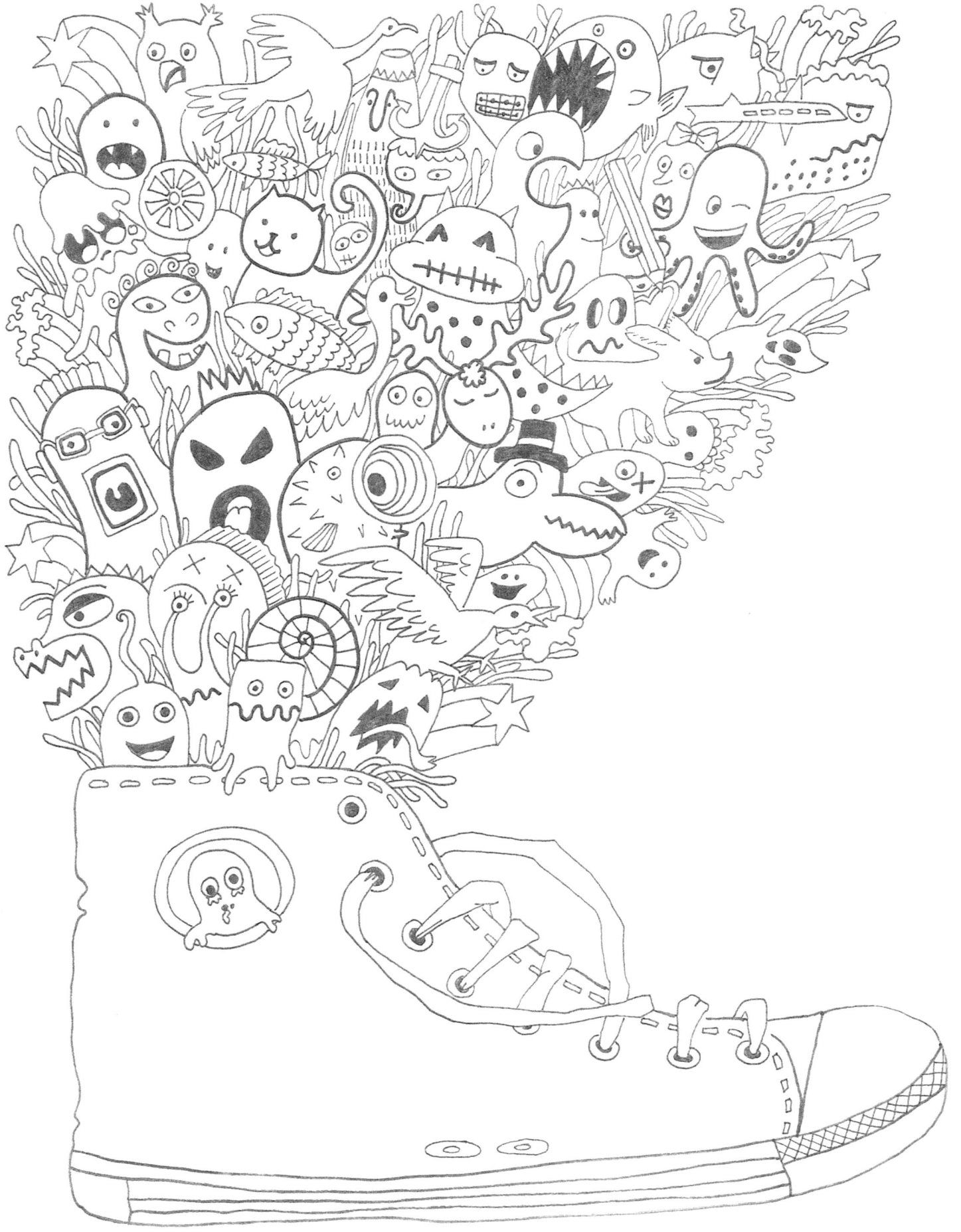

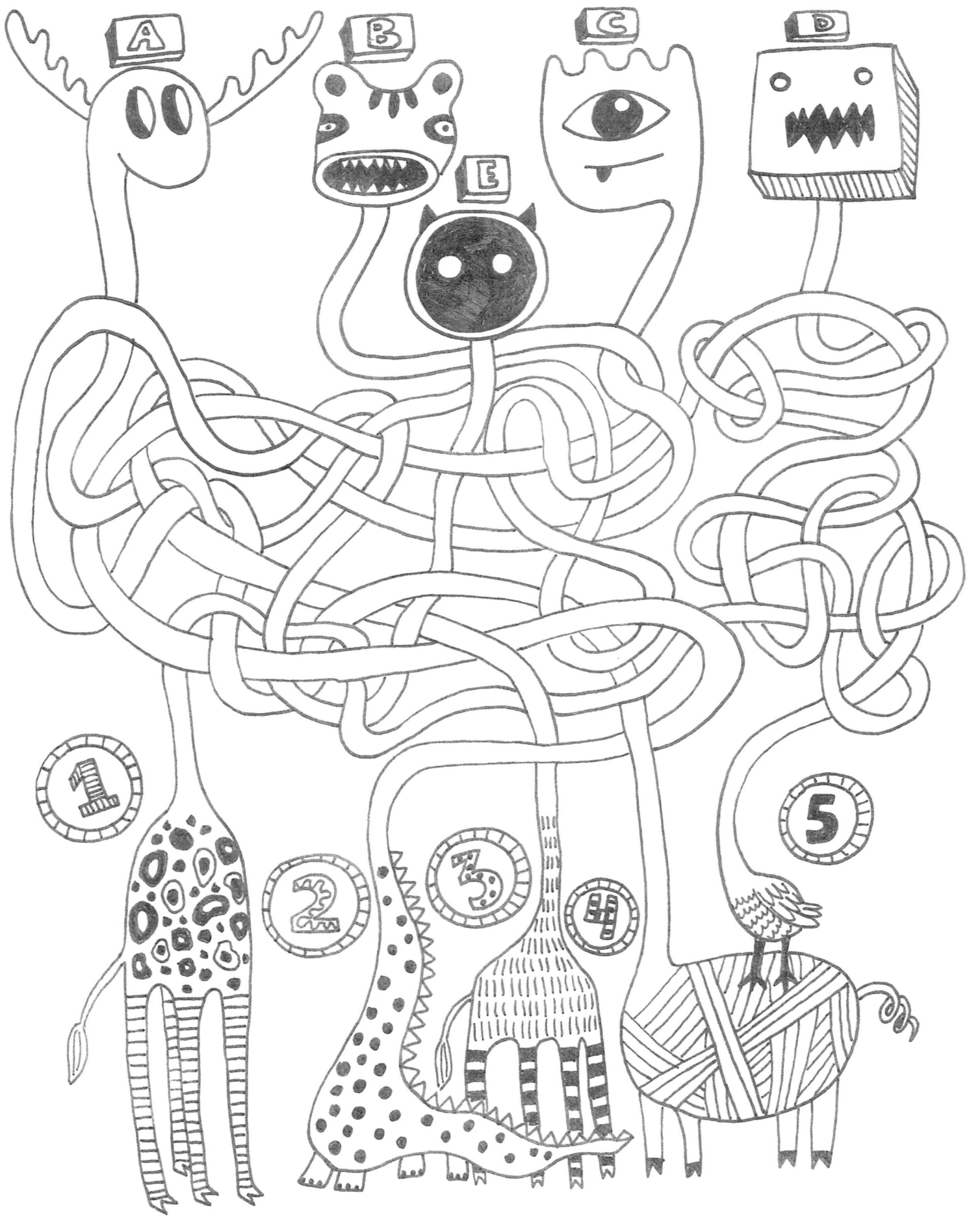

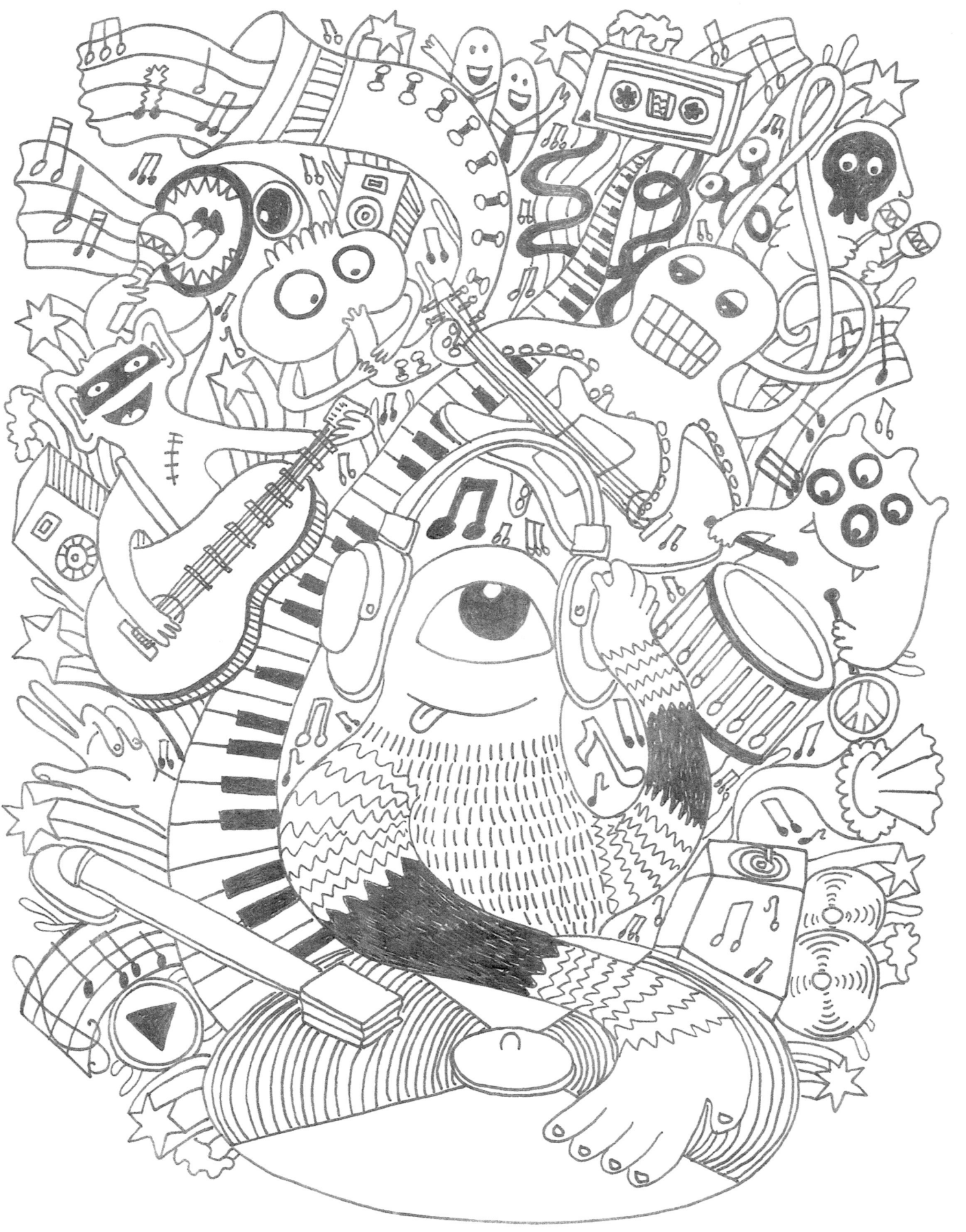

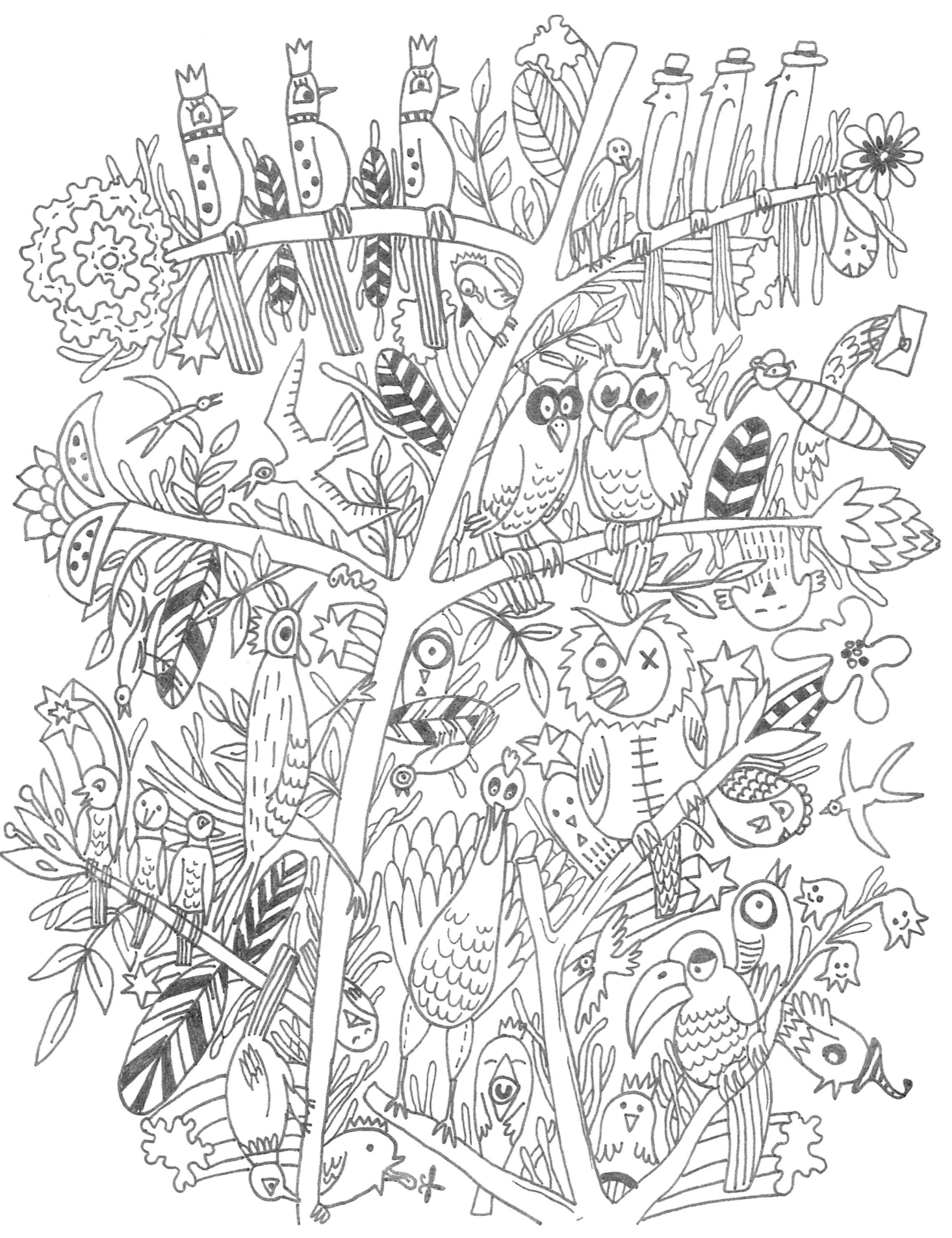

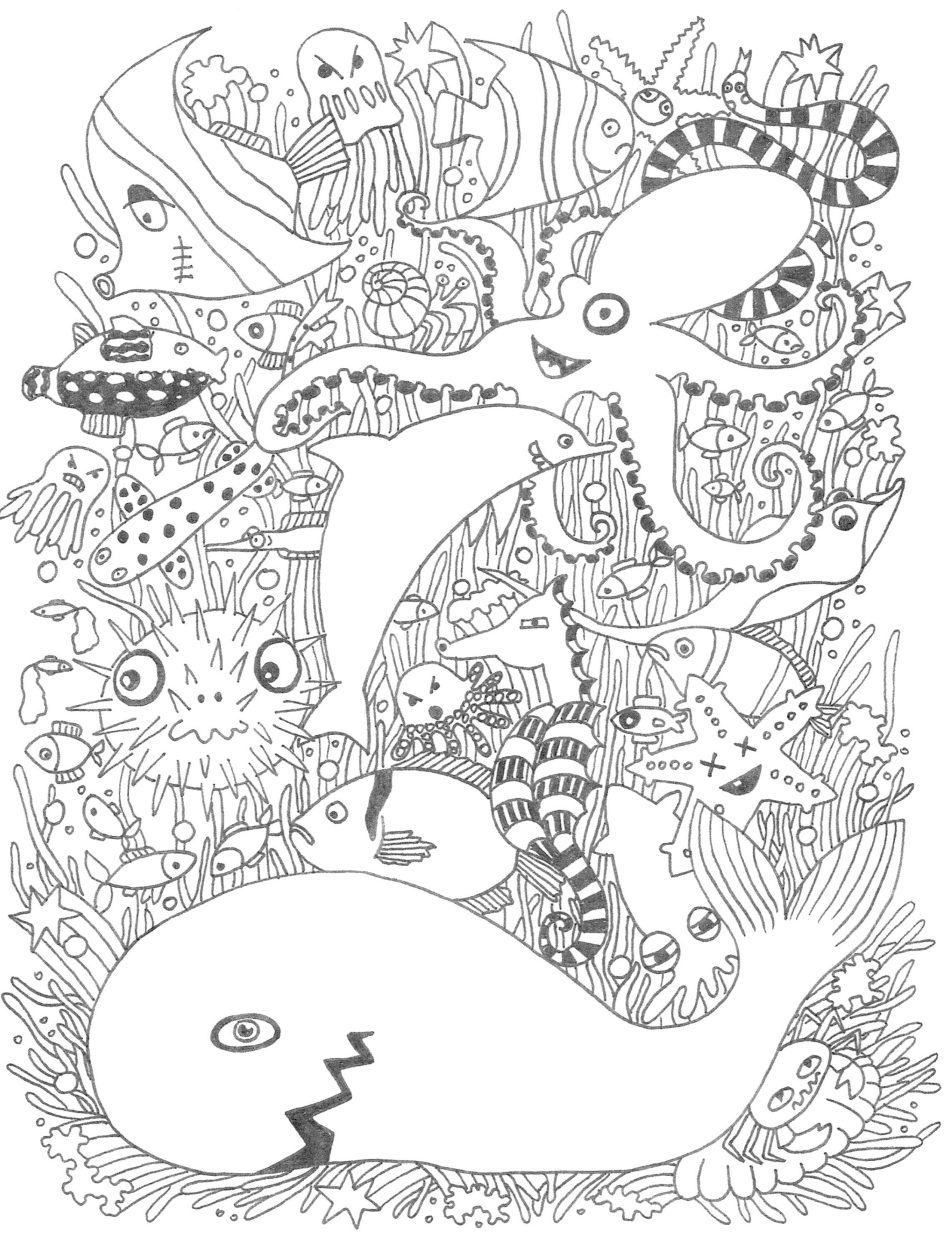

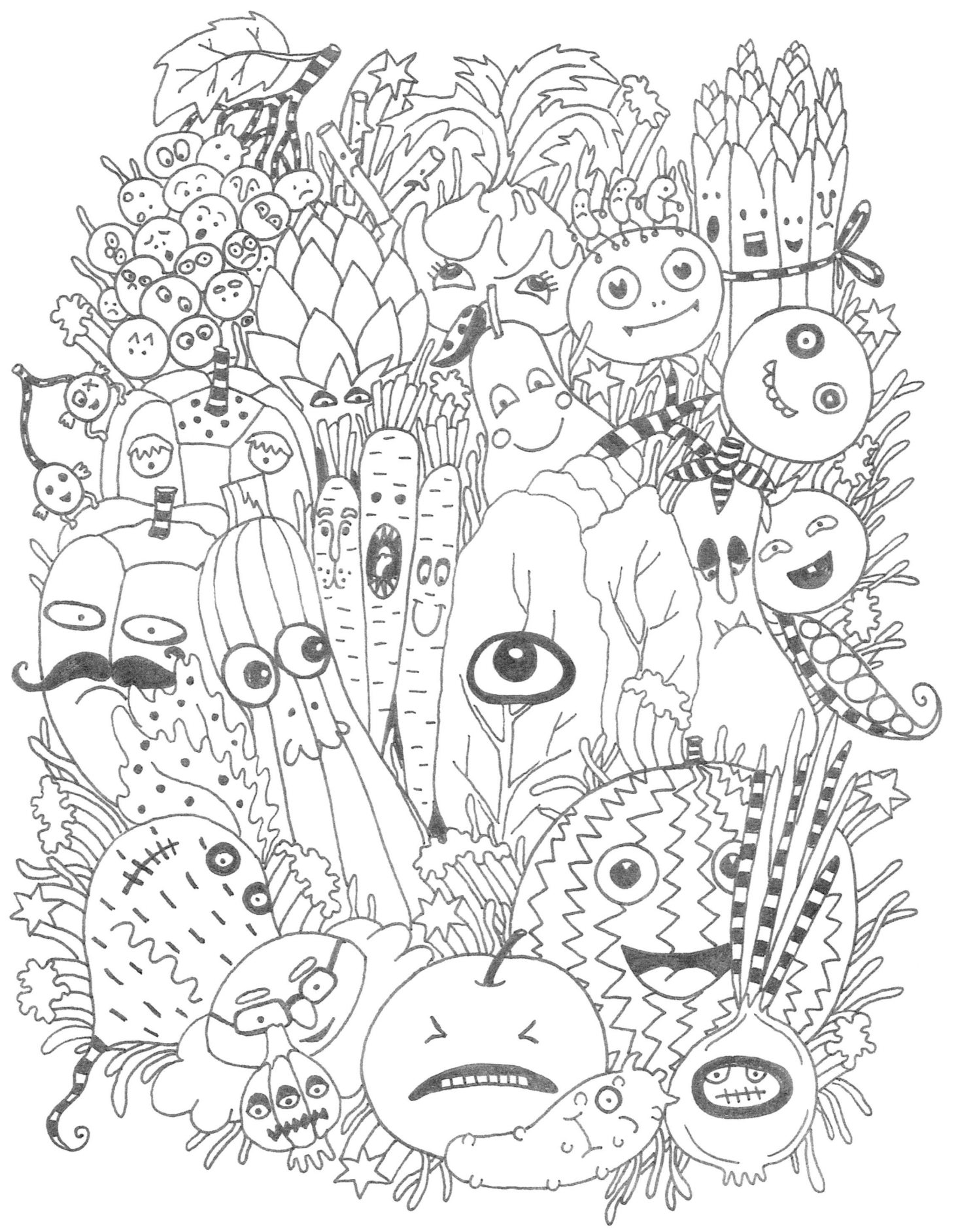

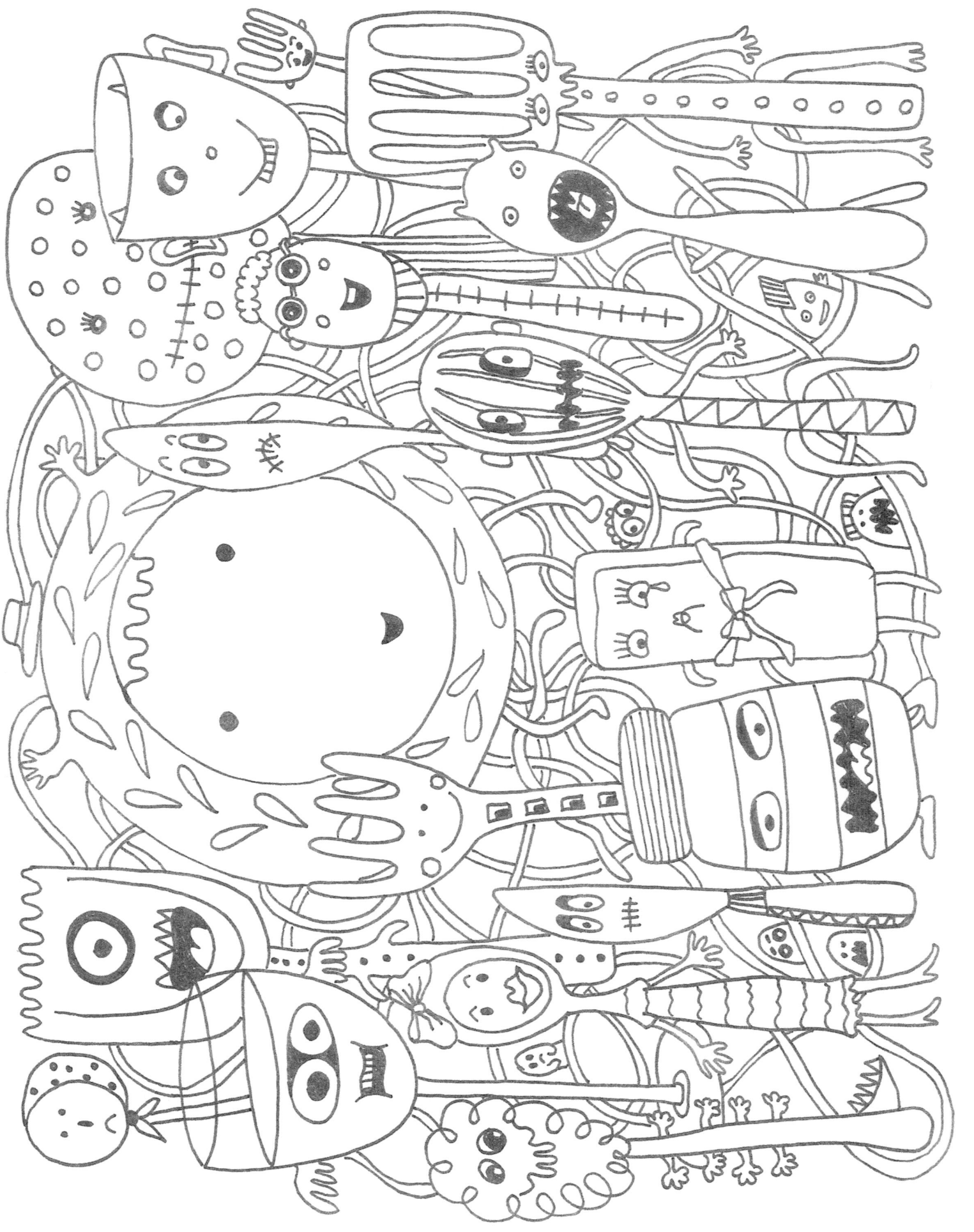

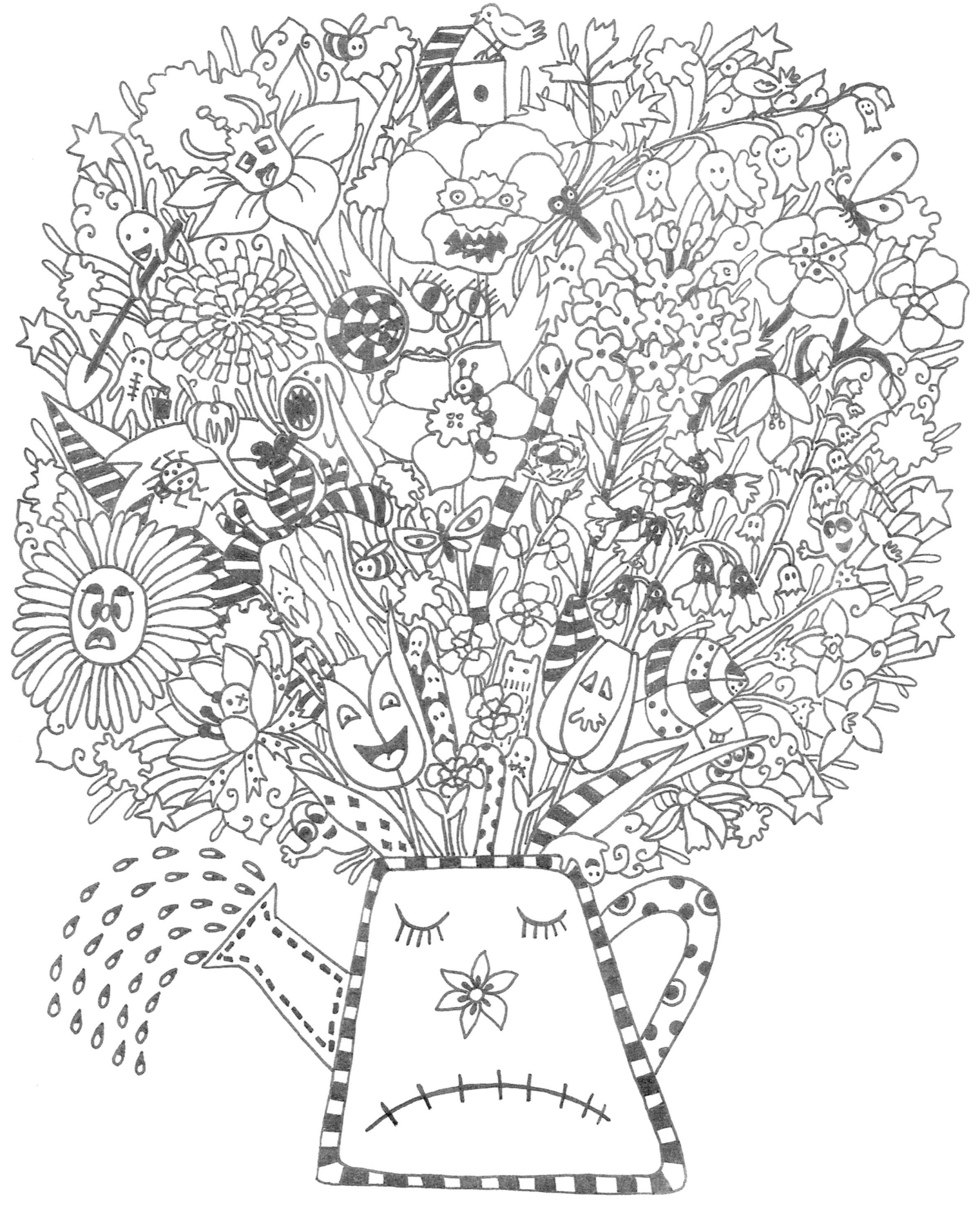

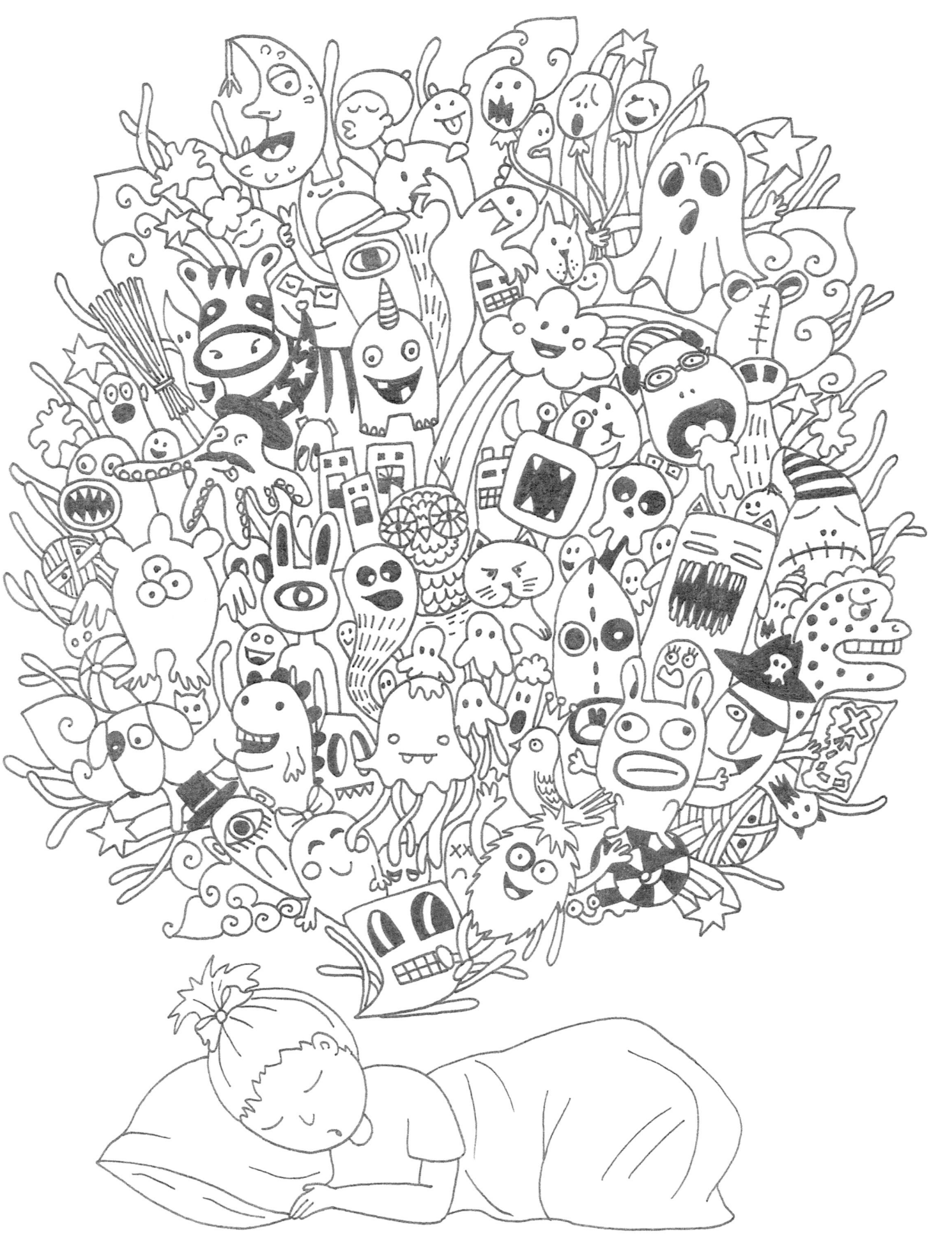

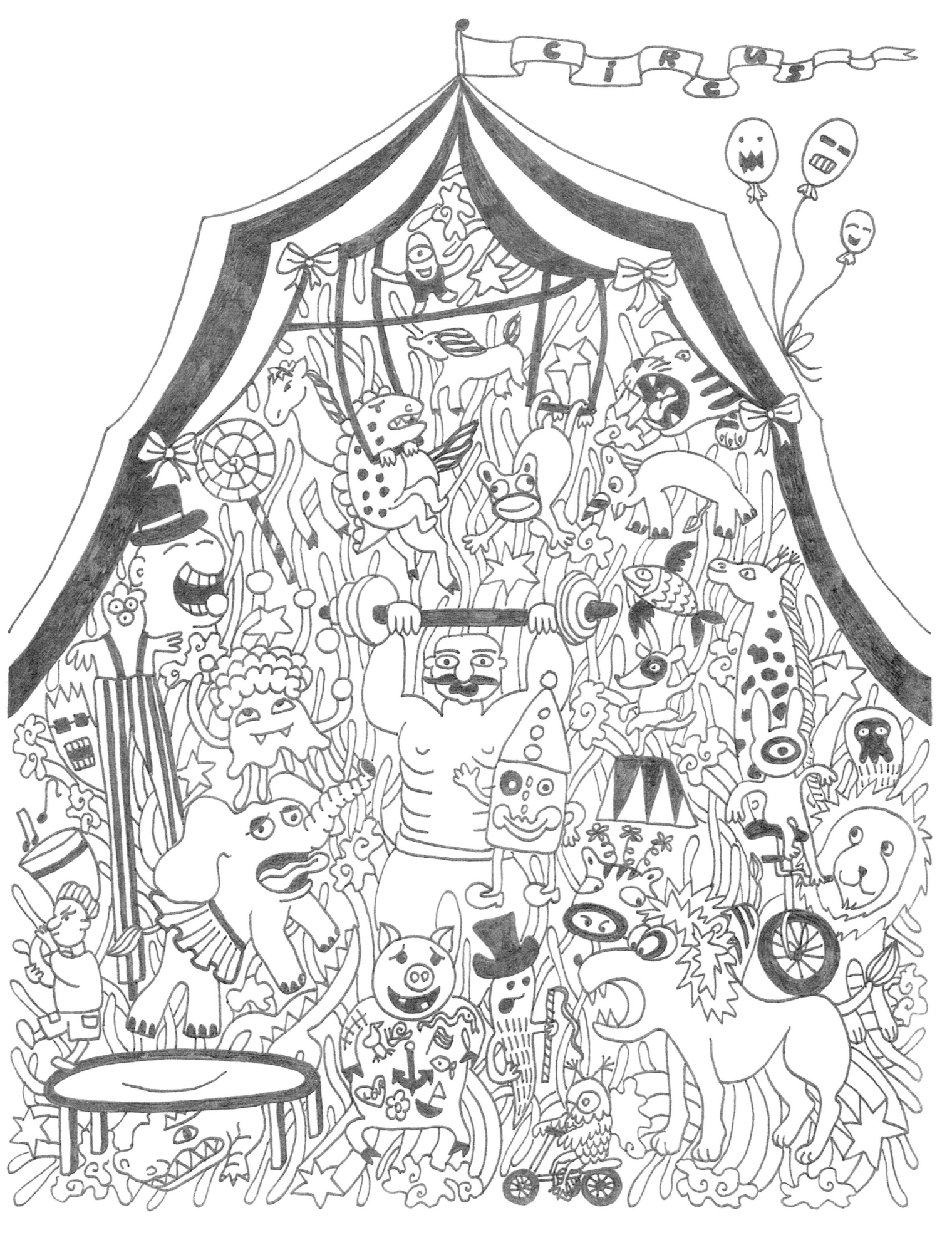

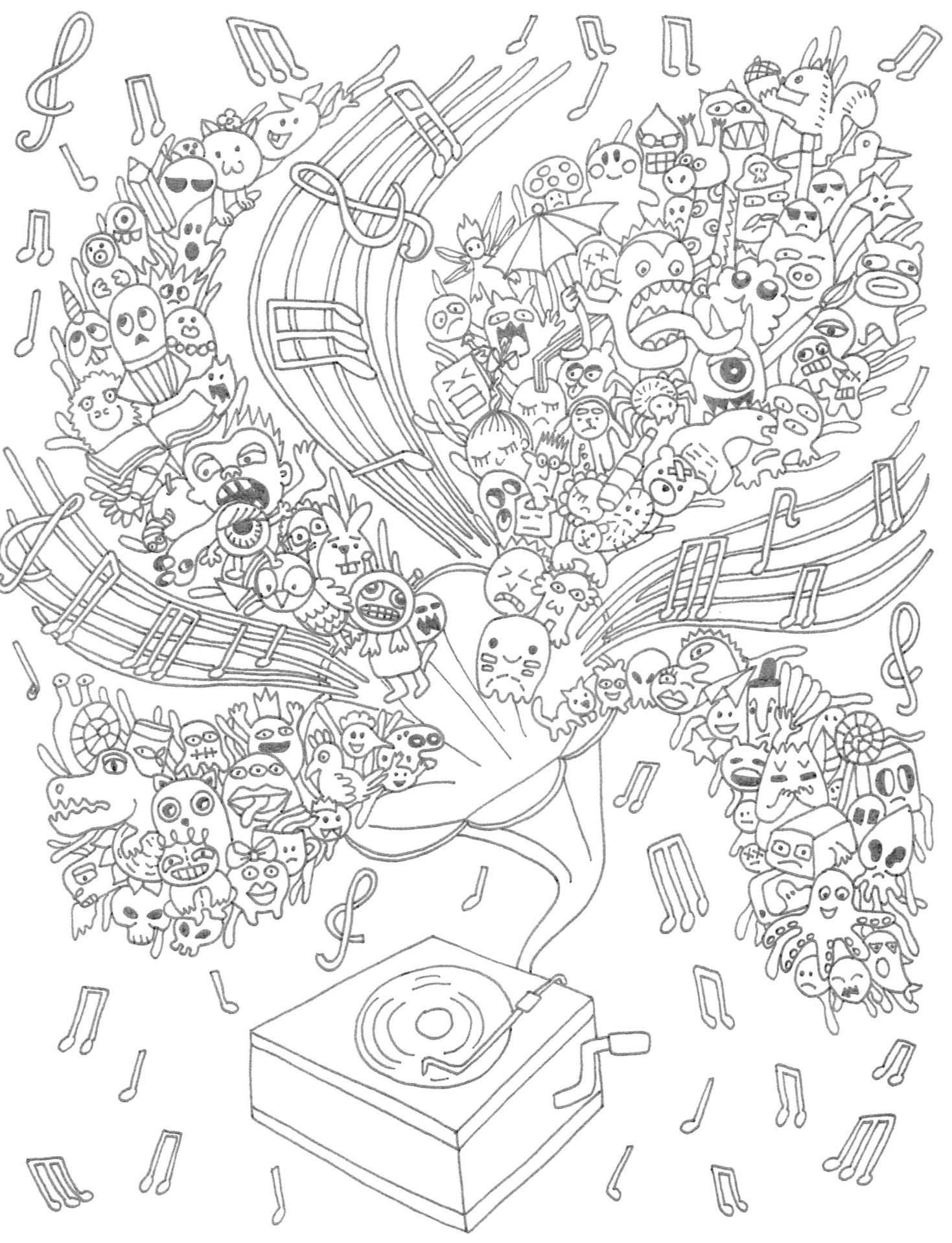

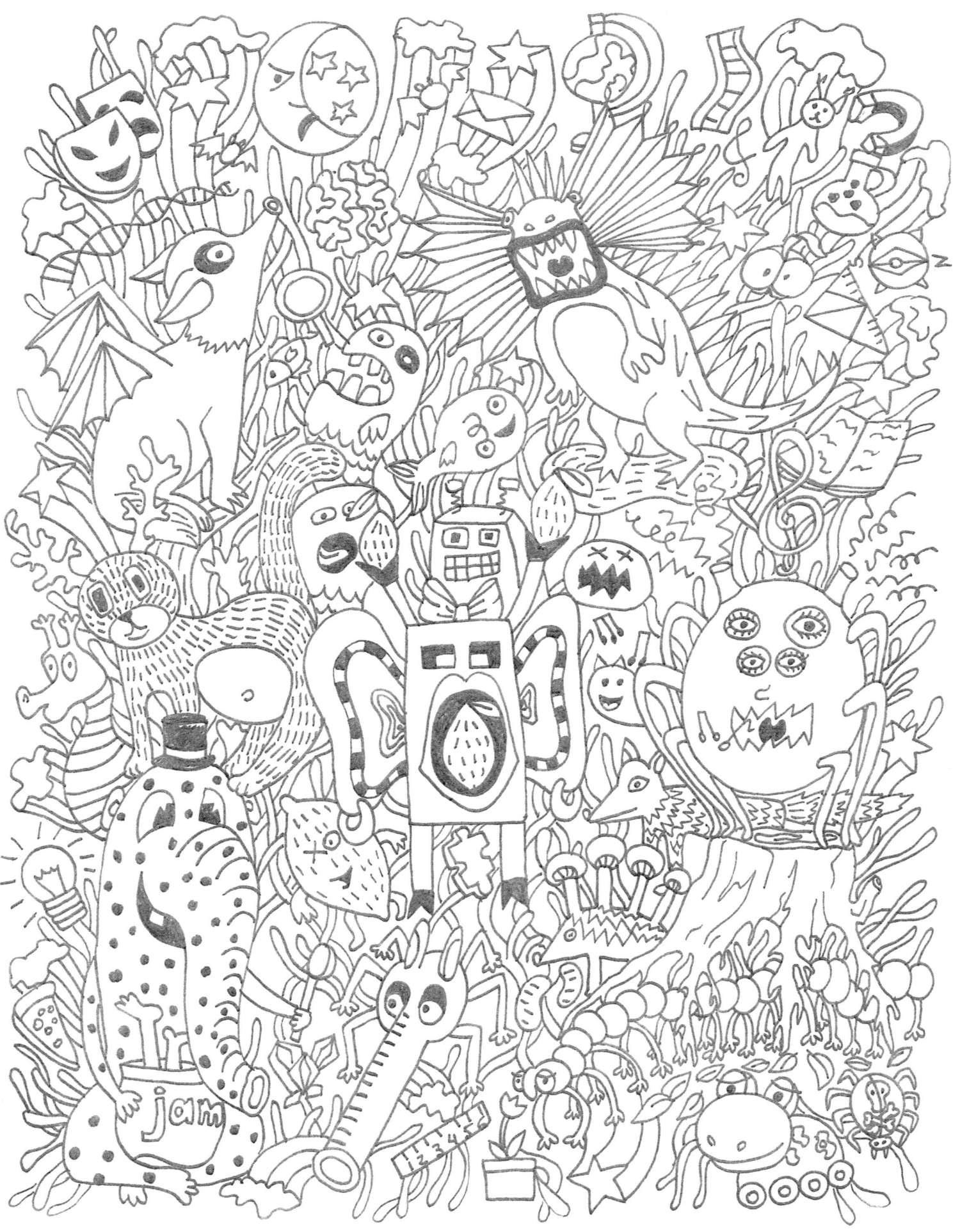

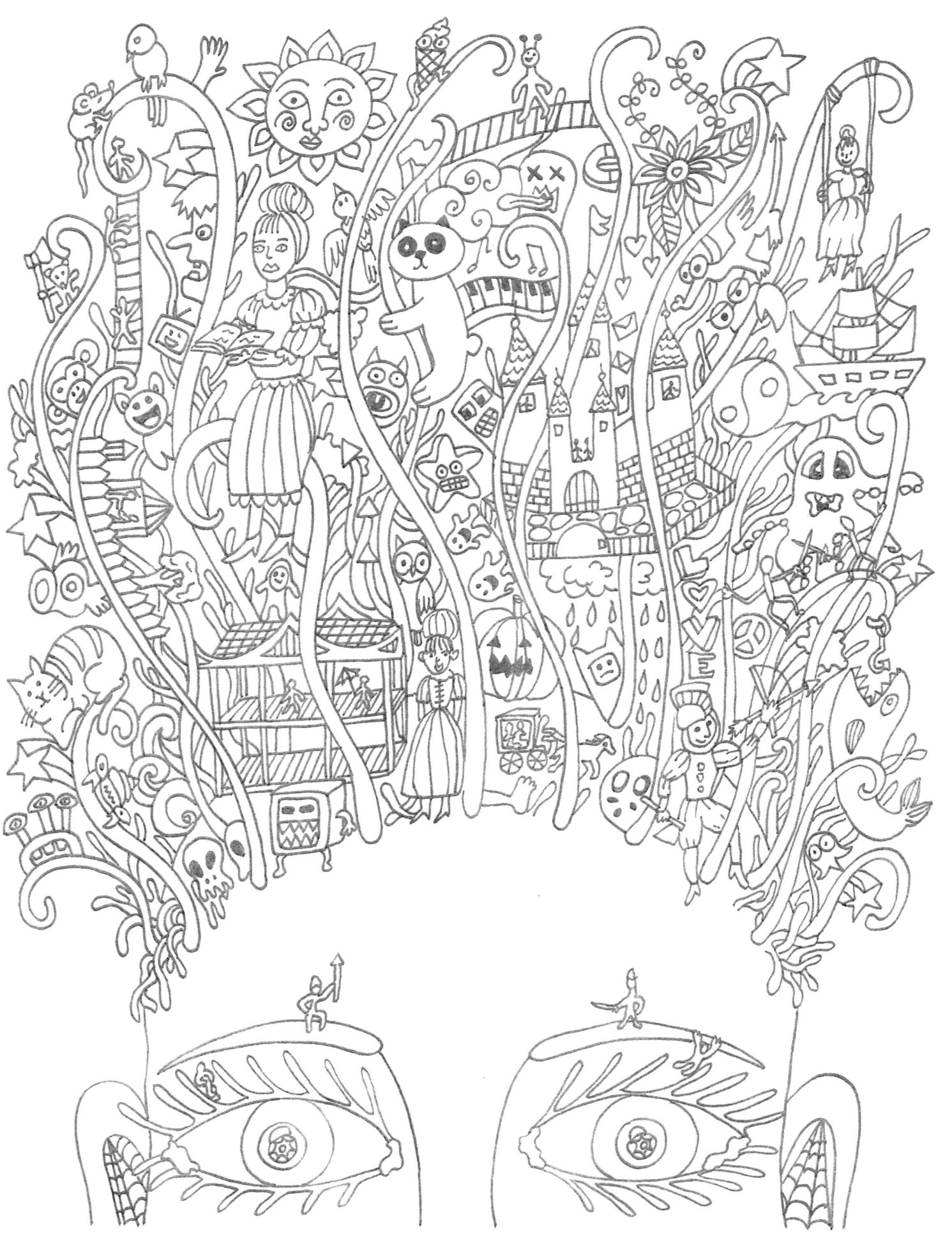

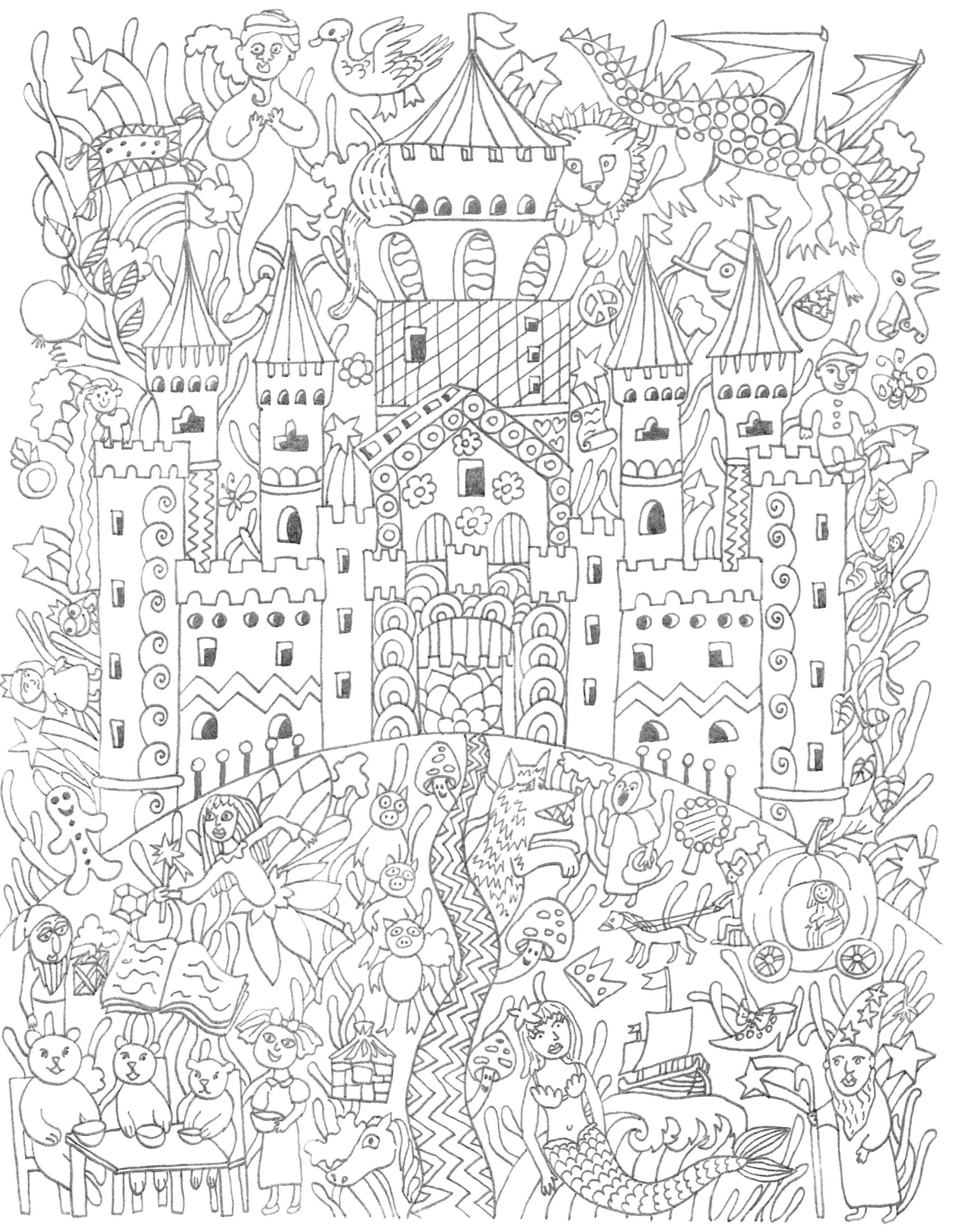

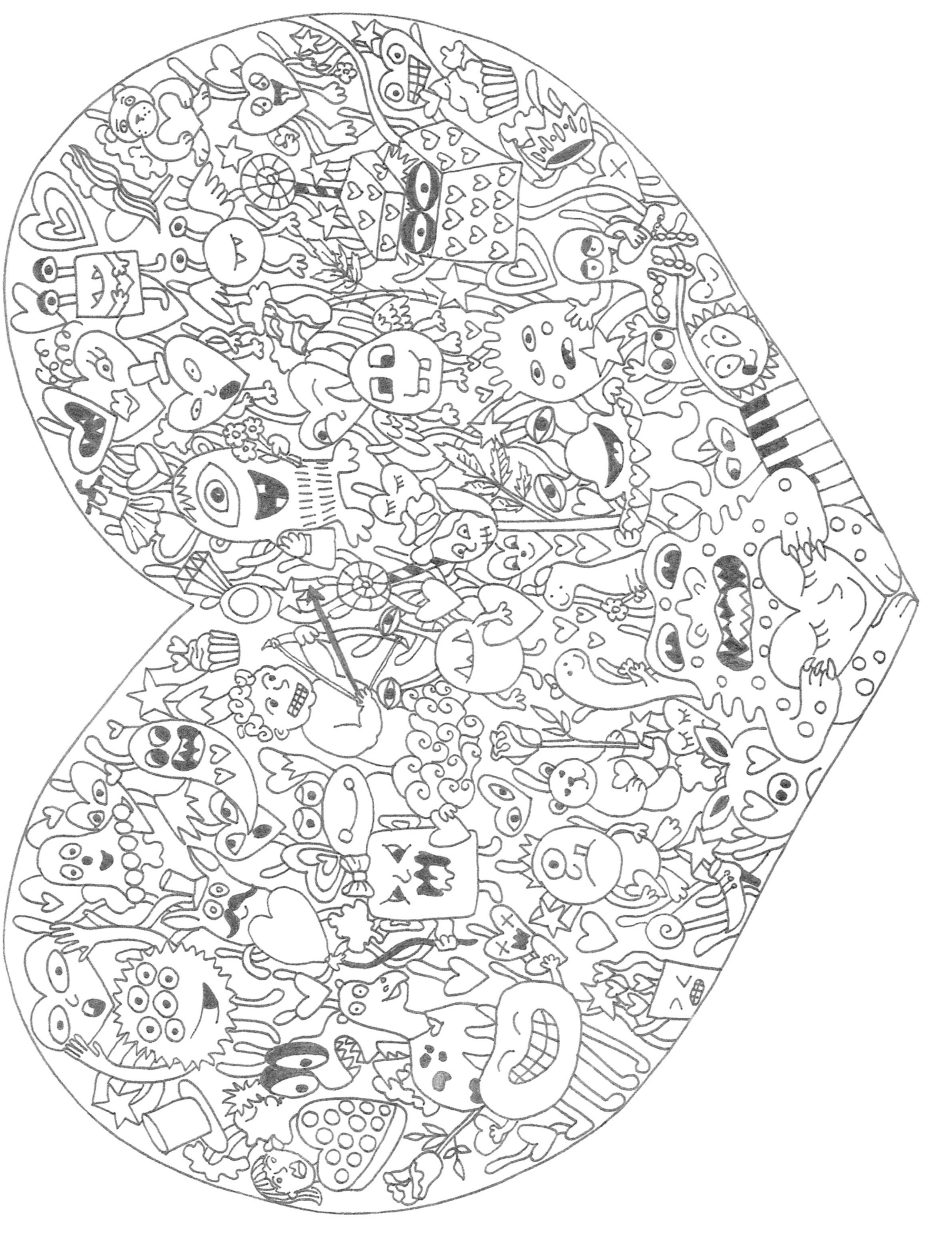

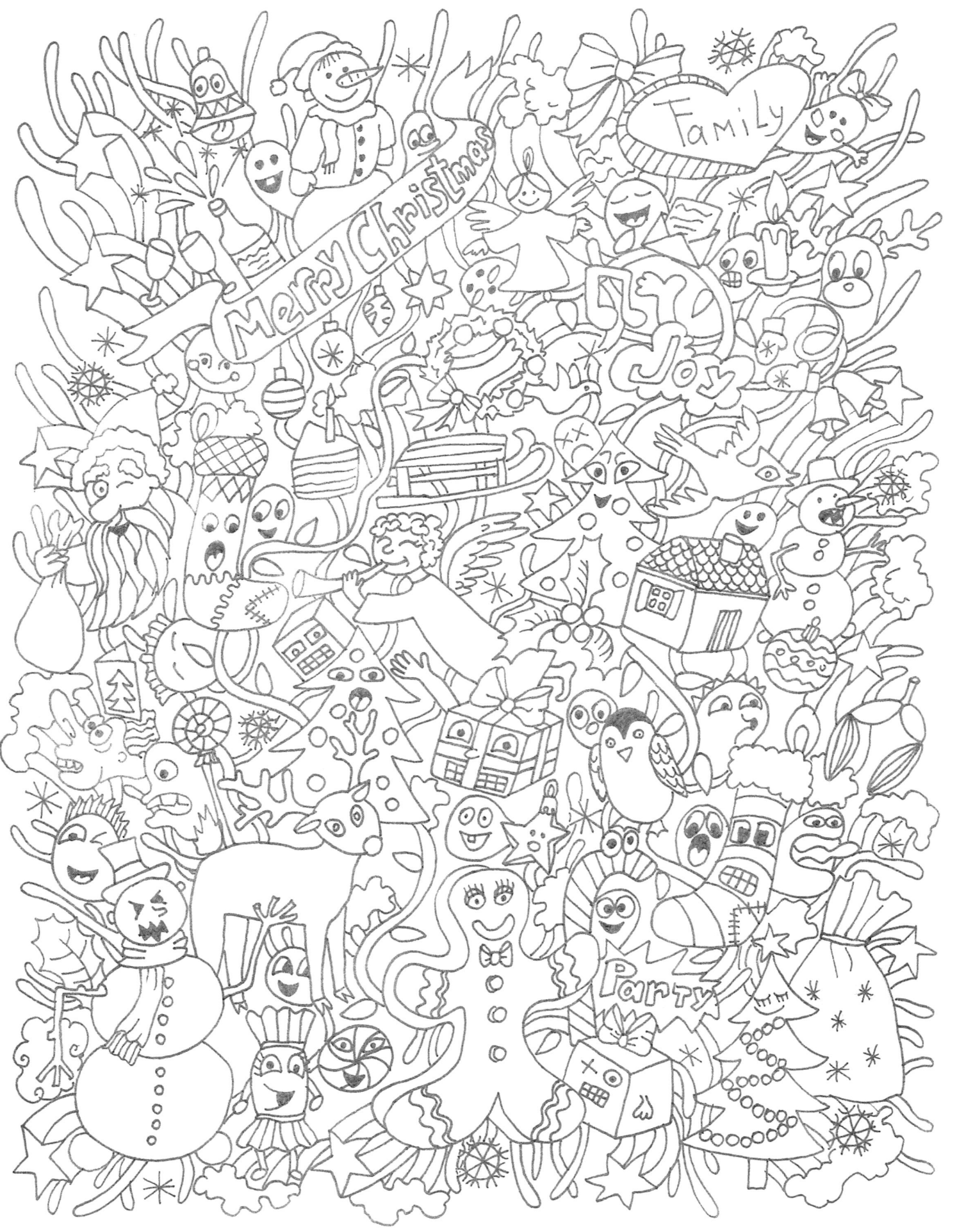

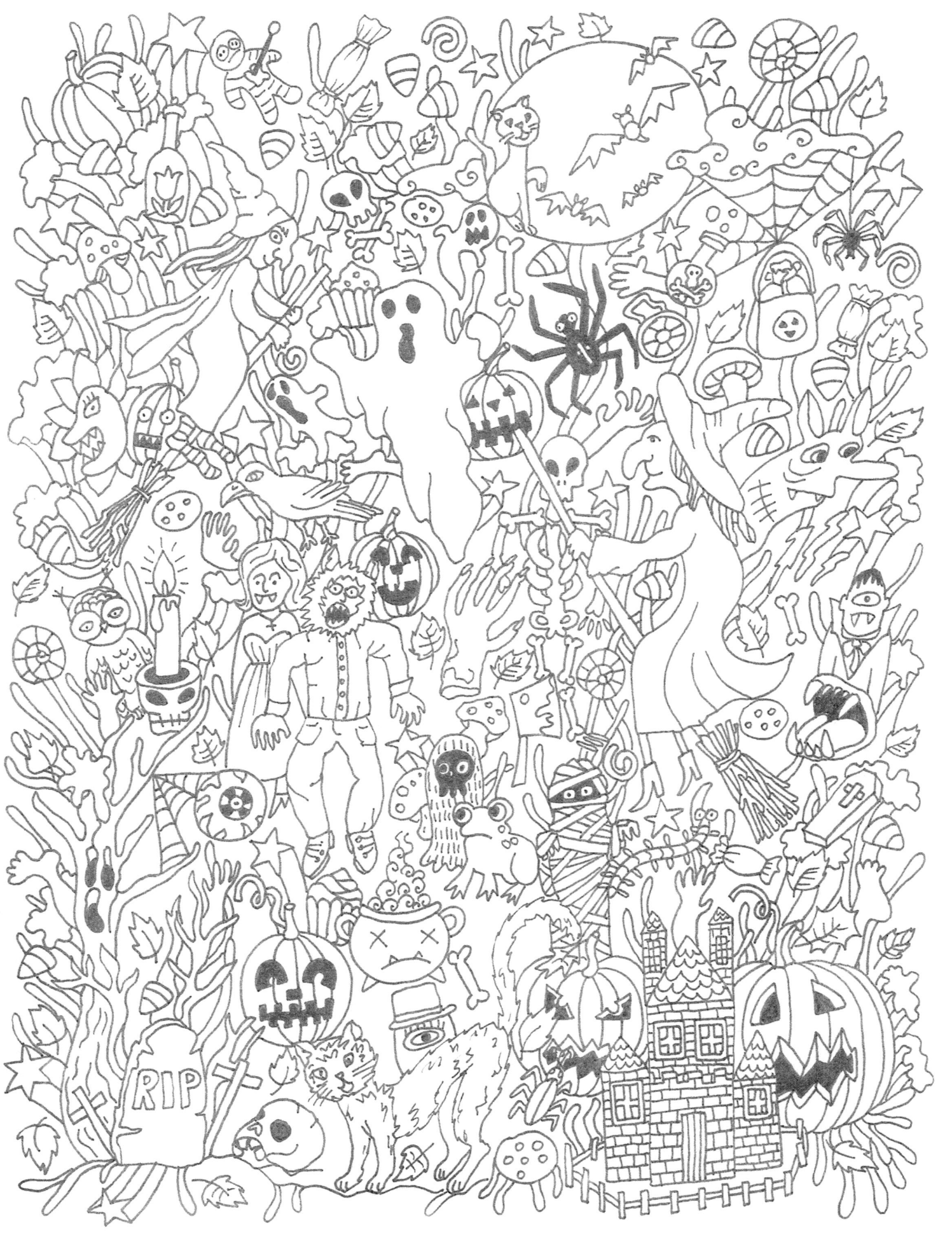

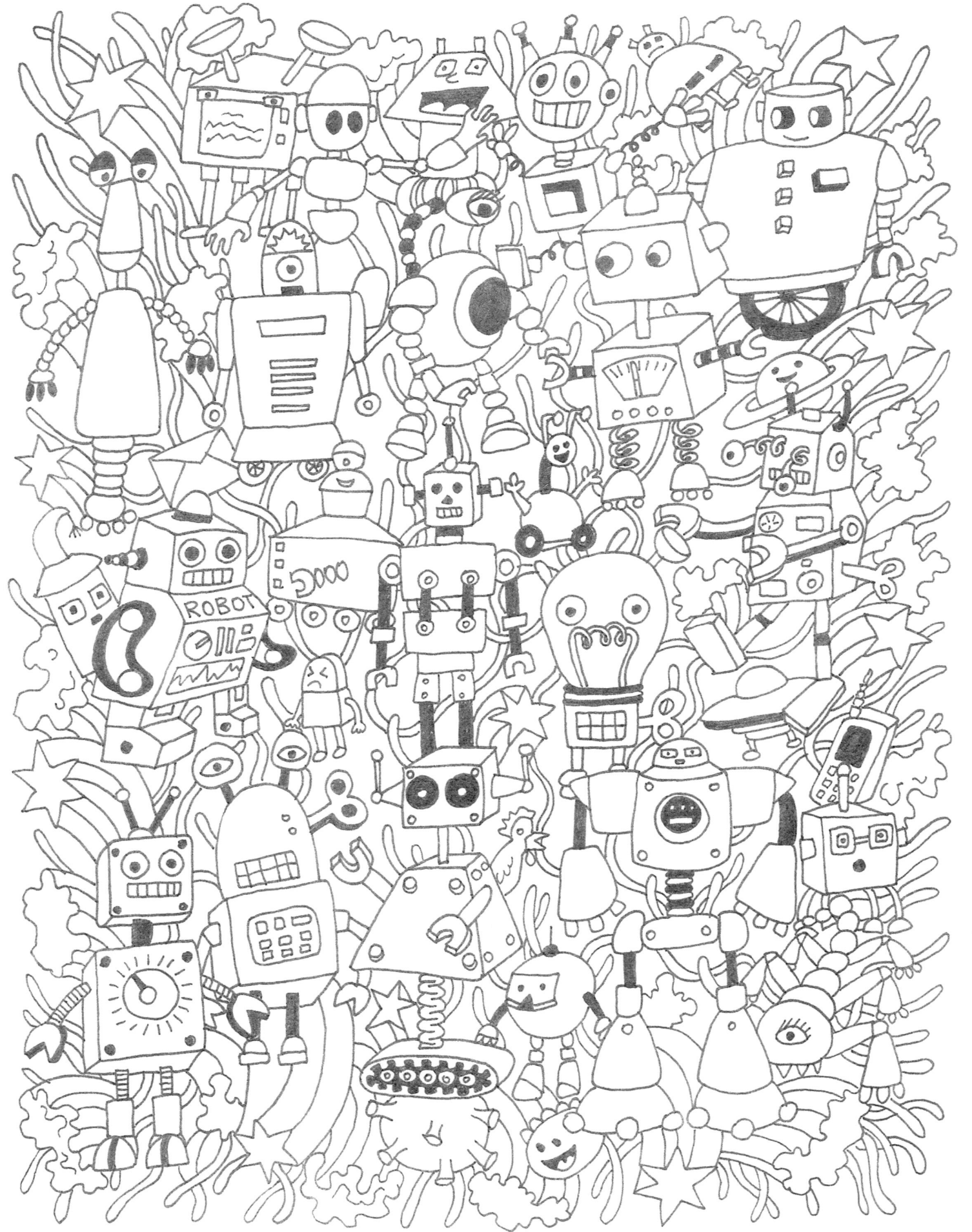

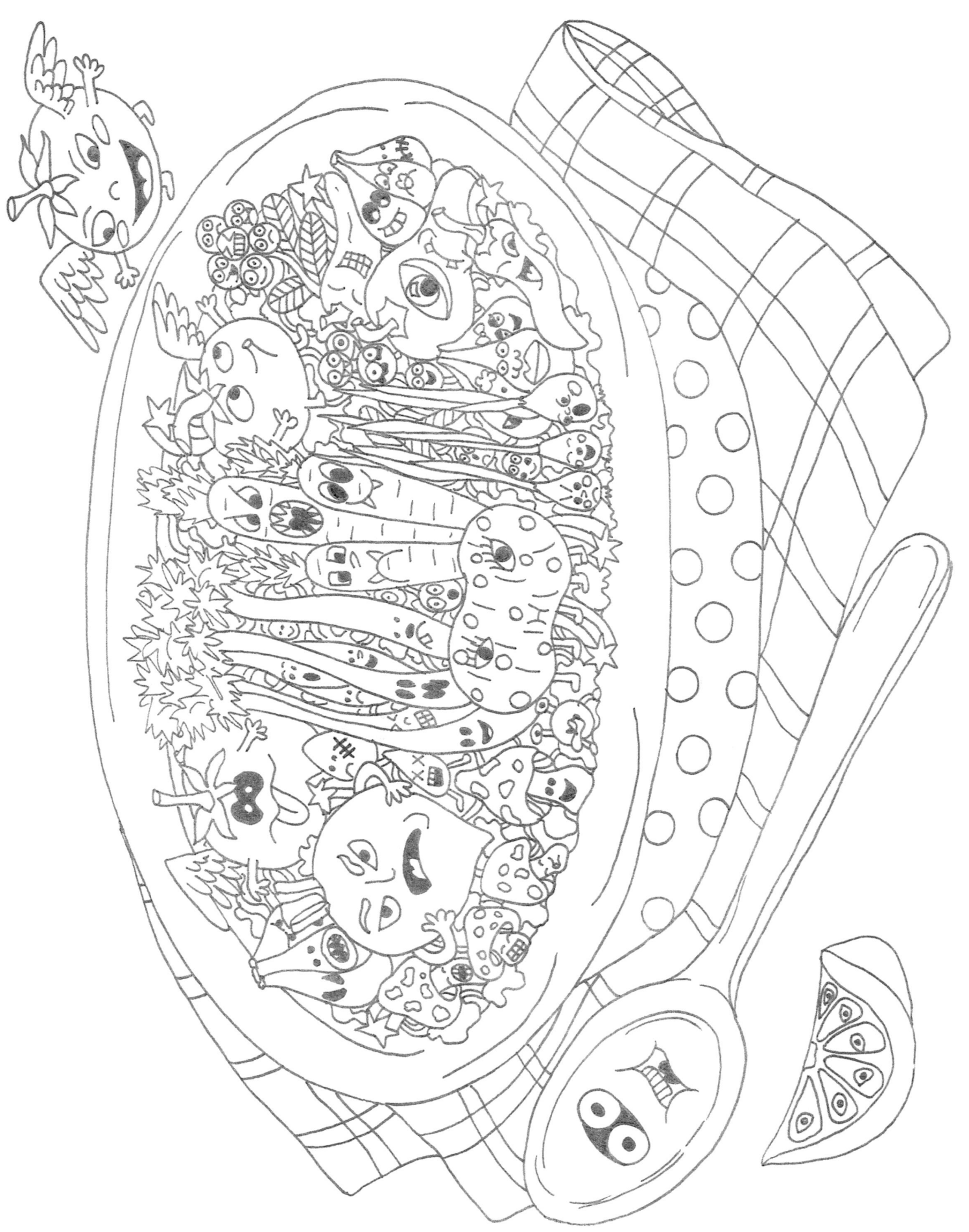